American Twilight

Cray McCally

American Twilight

SLEEPY BEAR PRESS ©

Minneapolis, Minnesota

Charleston, SC
www.PalmettoPublishing.com

American Twilight

Copyright © 2022 by Cray McCally

All rights reserved.

First Edition

Hardcover ISBN: 979-8-8229-0732-4
Paperback ISBN: 979-8-8229-0733-1

Acknowledgements

The writer would like to thank his family, friends, and the many coaches, teachers, and professors who have encouraged and helped him along his journey. Special thanks to those who have helped on this project; John McCally, Mike Zurbrigen, Tyler Hickman, Pete Sandvik, Tom Henderson, Kate Rock and most importantly Sophie Stephens for her work on the manuscript. Forever grateful to the many writers, artists, and musicians who have inspired me throughout my life especially The Grateful Dead, Soul Asylum, Husker Du, Meat Puppets, The Suburbs, Run Westy Run, The Delilahs, Mike Watt, Paul Metsa, James Loney and Lolo's Ghost, Edie Rae and The Blaze Kings, Dave Rave and The Governors, Frogleg, Walt Whitman, Dawnie Walton, Rita Dove, William Carlos Williams, Hilda Doolittle, and John Steinbeck.

Contents

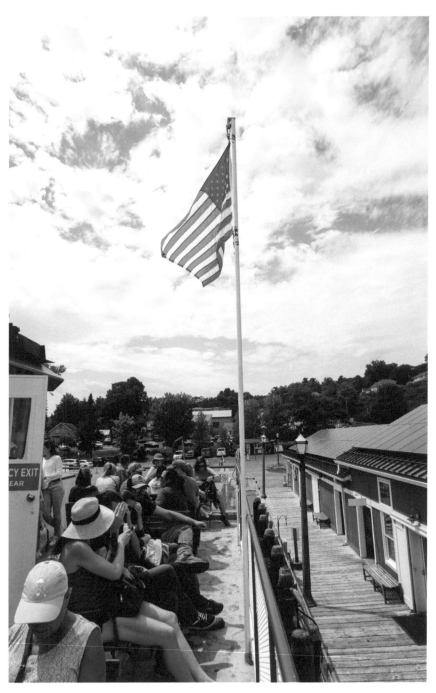

Aboard the ferry between Bayfield and LaPointe, Wisconsin

A Song Of LaPointe

Strong winds blow across the channel, whitecaps crashing on
Bayfield's shoreline, I sit inside the passenger cabin, watching
Family memories stirred up by the churning waters, headed to
La Pointe, my Mom has been riding the ferries over these waters

More than eighty years, my Gramma's family, Ashland, Wisconsin;
my Grandpa was a young doctor there, just out of University of
Minnesota medical school, courted Margaret Lytle, fell in love,
Married, before moving back to Minnesota, first Minneapolis, then

Rochester, dermatologist at the Mayo Clinic, our Gramma his secret
Power, she ran a tight ship herself, raised the children, organized his
Office, cooked and cleaned, got them through the Great Depression
Madeline Island has always been a refuge for our family, its pine trees

Sandy beaches, clear blue skies, polished stones and agates, lapping
Up Superior's waters, where we learned to swim and water ski, bonfires
At night, hot dogs and s'mores, my brother and sister and I playing with
Allison, Stacy, and Jayne, daughters of my Mom's best friend Marjorie

The fog, a late summer's morning, absolute stillness reigns, except the
Sounds of boats far off, fishing for lake trout and whitefish, small clouds
Rising from the waterline, I long to taste your serenity once again, I run
To your hold on my senses, to capture the spirits of our childhoods, oh

Madeline, to hear your siren's songs, into the void we followed, the scent
Of her flowers budding in springtime, splashing in your icy waters, walking
Along the paths at Big Bay, looking out at the Apostle Islands, it is here in
The loon's commons, where my soul will always wander, once more I return

Along This Canal

Along this canal, I sit and listen to the Gulf breeze blow in from my West
Storm clouds drifting slow as the wind shakes the palm trees, the morning
Sits gray and cool, but the birds still call out and sing their soothing songs
This land, at once ancient and brutal, holds a particular beauty all its own
Your mind stretches back as far as your imagination will allow it to, back
To the days when this was grasslands and swamps, hear it echo with the
Sound of discarded memories, the footsteps of mammoths, bison, giant
Land tortoises, and the mighty mastodon, chased by prehistoric hunters
Florida's first peoples, in communion with the land, water, and animals for
Over 10,000 years, until the arrival of the Spanish in the 1500's brought
Pestilence and sickness to the people who had come before, had made
This land their ancestral home, to be forced out of those homes into the
Interior, the Everglades, then along the Atlantic Seaboard, the Gulf Shore
Facing down guns and forces, ships and cannons, colonial powers attempt
To seize its riches, searching for silver and gold, they'll battle the Spanish
Before Andrew Jackson will battle the Seminole, the United States will be
Next to try and impose its will, on this place rich in its own history, this land
Once ancient and brutal, where I now make my home, to sit along this canal

Like A Dream In Springtime

Wake me I can't wait much longer
Stowe away on this spaceship with
Me, we can take this trip a little bit
Higher, the day is there for the taking

Sweet songs will fill the morning air
We'll chase the sun across the sky
Breathe in the fires of this sunset
Ride out the twilight and watch one

Star rising above the horizon, feel the
Pull of the moon upon our heartstrings
Preparing us to dream again, to stretch
Out as the world slows down to a crawl

Southern kisses from her window, lonely
Rivers jutting through the swamplands
Cutting across the pine trees, cypress, and
Under the strands of Spanish Moss, from

The back bays where the osprey circle
Above the canals and shoreline where
The brackish waters splash onto a white
Sand beach, nature's bounty awaits our

Return, our souls gently shaken as we
Search for a bit of new found hope, let's
Ride through this dream together, one arm
Draped loosely over the other's shoulder

Walking towards another golden sunrise
Candy apple kisses and the beating of our
Hearts in time to the rhythm of a favorite
Song, wake me gently, it is now our time

On The Family Farm

They sat upon an old porch, spiderwebs hanging in the corners
On the windowsills, under the eaves, it was only just past noon
Dust hanging as heavy as the humidity, a hot breeze blew up
From the south, trees beginning to turn green, late May sun out

To the edge of the creekline, a few head of cattle dot the land
These rhythms of the season churn eternally, planting their seed
Waiting for the summer rains, praying that the storms aren't so
Bad; hail won't damage the early stalks or leaves, won't flood the

Fields, won't leave their crops wilting, or dying before the harvest
Gramma pours the lemonade, she has lunch set upon the table
Fried chicken, mashed potatoes with gravy, slaw, green beans
Hot rolls fresh from the old kitchen's oven, it has served them for

Over forty years, lean years, hard years, good years; changing
Years, now monster combines work the fields, small town co-ops
Replaced by corporate shipping yards, two tracks running in and
Out, rail lines humming with the bounty of the land, towards the

Cities and towns where the grandchildren now work and go to
College, a flock of ducks flying towards the Canadian border, they
Angle away from the sun, soaring as they catch the wind's drifting
Current, they hold true to the generations that have flown along a

Path enjoined in memories deep in their bodies, wings flapping in
Midday heat, tomorrow more flocks will join them, to the lakes and
Rivers where they'll summer, but for now, they are one within many
Circling above the promise of another spring's planting and growing

As Summertime Begins

The turbulence continues, in these shadows
Where darkness descends, shimmers, and
Dims, one star rising bright, in pale corners

The night envelopes day, sunsets across a
Clear blue lake, summer's coming on strong
As a cooling breeze wafts through the pines

Dancing across treetops, a blur of colors wait
Far out on the horizon, kids playing games on
Sandy shores where their grandparents used

To hike, fish, and swim; nothing really changes
Though it never stays the same, time marches
Onward, resolute in its solitary path, it hears a

Voice cry out in the distance, this is how it began
How it all started, where red clay meets limestone
The small creek will rush, to meet this surging river

Under an eagle's watchful eye, above the pines
Oaks, maples, aspens; it circles above in sunlight
Dimming, before the rush of those coming up to

Their cabins, trailers, and second homes; passing
The old lake resorts, drive in restaurants, supper
Clubs; time evaporates when summer time begins

Long Misty Daze

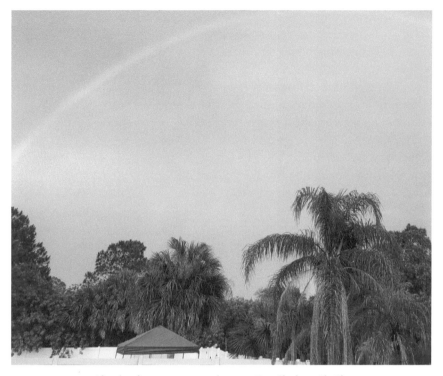

After the afternoon rain, a rainbow over Port Charlotte, Florida

Thick and humid, the air felt more like late April than mid-February
Fog was thick along the Gulf Coast, a slight spit of mist as I got on
My bike, my morning ride, the neighborhood was slowly coming to
Stir, a couple of Scrub Jays picking at a trash pile next to our street

A pair of doves cooed from the wires above, a neighbor waved as
They got into their truck for work, Friday morning at 7:15, another
Day of construction in Southwest Florida, the city keeps expanding
Snowbirds and Midwesterners moving down to the Sunshine State

Leaving behind the chill of winter, the darkness, cold wind, snow
Swirling from slates of gray, the sun now shining a bit brighter, the
Days now a bit longer, but here, in this peninsula between the Gulf
And Atlantic Ocean, the fog will burn off, and it will get up to around
80, I turn onto Chancellor Boulevard, Hwy. 41, as Tamiami Trail runs
Parallel to the boulevard on the other side of an Aldi's and Perkins
Restaurant, they were once the biggest restaurant chain back in my
Home state of Minnesota, they too have headed South in their silver

Years, life like an endless loop of scenes from times before, see me
Walking through the Mission back to my sister's apartment in San
Francisco, the fog heavy, wind coming hard off of Pacific Ocean as
I walk backwards through space and time from La Cumbre, carne

Burrito in my backpack, sounds of shuffling feet, the neon lights try to
Cut through the late afternoon, night is coming on, I turn right into this
Memory, my momentum carries me towards the canals of the Myakka
River, but is caught up in the remembrance of so many long misty daze

The Man In Black

JR Cash, Johnny Cash, The Man In Black, America's favorite son
50 miles from Memphis in the heat of the Mississippi River Valley
Working with his family, cotton fields of Dyess, Arkansas, he first
Started singing gospel, songs that fueled the soul while sweating
And straining to fill cotton sacks with his brothers and sisters, how
High is the water, Momma? Five feet high and rising, life was tough
His brother killed in an accident working a table saw when JR was
Only twelve, he poured out his grief by writing poetry and songs, he
Learned to play the guitar, began singing at school and in the church
Before he joined the Air Force, cold warrior intercepting Russian code
From his base in Landsberg, Germany, started his first band there,
The Landsberg Barbarians, discharged in July of 1954, moved back
To Texas, married his first wife, moved to Memphis, started his family
Playing nights with the Tennessee Two, Luther Perkins on guitar, and
Marshall Grant on bass while selling appliances to make ends meet
He auditioned for Sam Phillips at Sun Records, who told Johnny that
They weren't producing Gospel anymore, hopped on the rockabilly
Train with Hey Porter and Cry! Cry! Cry! , next, Folsom Prison Blues
Before, I Walk The Line went to number one on the country charts, and
Broke into the pop charts as well, sang with Elvis, Jerry Lee, Carl Perkins
The Million Dollar Quartet, made the move to Columbia Records 1958
Where he recorded Ring Of Fire, outlaw rebel coming into his own but
Wrestling with his demons; uppers, downers, strung out on the pills
The Lord and the Devil battled for his life, heaven and hell, struggling
To stay clean, he knew of the troubles that the working man and woman
Faced, sympathized with the downtrodden, prisoners, Native Americans
He helped bridge the many sides of America together during its time of
Turbulence, late 1960's, unraveling and fighting it out on city streets,
College campuses, and state capitals, his tv show brought together the
Range of American voices, Dylan, Joni Mitchell, Neil Young, Ray Charles
Louis Armstrong, Roger Miller, Roy Orbison, Linda Ronstadt, Mahalia
Jackson; he looked out at the whole of the nation, unafraid to call out

The things that were destroying it while always looking to make it better
He earned his trust, integrity, and appreciation from the American people
He and June got married in a fever, hotter than a pepper sprout, she
Supported him through good and bad, thick and thin, America came to
See the love that they shared together; he rode with Kris, Waylon, and
Willie, The Highwaymen, country music's supergroup, playing songs that
America had come to know first hand, his career revived in the 90's, his
Work with Rick Rubin, the American Recordings, the coda to a life well
Lived, he shook the rusty cage, spoke with his very own personal Jesus
Came to terms with the hurt that he had traveled with his entire life, not
A surprise that he passed shortly after his beloved June did, he had made
It back to the fields of Dyess, in the clouds of eternity, at home with His Lord

Winter's Promise

Ravaged thoughts upon the winds of change, tomorrow cannot replace
These fragments of time ripped from our hands and memories, the die
Has been cast in stone, yet mountains still crumble to raging seas

Where is the love, and hope that we were taught to worship when we
Were young, innocent lambs playing in fields of green under sun drenched
Skies of blue, now we must turn and face the storm alone my friends

With solemn hearts and tattered souls we wonder how does one deliver
Justice in times of such turbulence and strife, how do we honor the simple
Things that bind us, all together, despite the distances that reside between

Us, it now feels so, so far away, so many broken days, broken nights, no
Sleep, no peace, too little reconciliation, are we holding out or holding on
Balls of confusion raining down upon each and every one of us, hold tight

To ones we love, those still hurting, still seeking, those who have walked
Hard miles through winter's chill, as if waiting for redemption in spring's
First rains washing away April's icy crusts, and farmers start to till the land

I look around at the workers sweating through their day, to grasp at baby
Fingers when they get home, they realize the future's promise, how grace
Is a blessing, our path stands clear, forgiveness must steel the hurt we abide

Roaring Fork Valley

How much life has traveled along this river, ancient trails of fox, coyote,
Deer winding down the mountain into the scrub pine along the river's jagged
Edge boulders slowly shaped by millions of years of the snow, wind, and rain;
I stare at the sloping sides of a canyon, rapids claw their way through ancient
Formations of granite, gneiss, limestone, sandstone, basalt, marble; a billion and
A half years the land holds its record of geologic change, it marks its past over
Eons, imperceptible to the human eye, life moves at its own pace here, imagine
Looking out into this vast country, untouched by civilization, gatherers
Moving into the future where history will see the arrival of the hunters and
Chasing big game, then the villagers growing corns, beans, squash;
Colorado with its mixture of plains, mesas, mountains; rising up from tectonic
Plates, volcanoes, and violent explosions, dried up inland sea, all work
To touch our sense of wonder, rolling down like melting snow in the spring
Sunlight, always traversing between the past and the future, places that bind
Us together with the powers of nature, and where our imaginations hold what
Tomorrow will bring, torrents of water flowing through this river, running cold
And free

Quiet Of Remembrance

Tomorrow, she said, maybe then I'll
Touch the stars, yet the years keep
On slipping through her fingers, as

Doubt raises the challenge that she
Must face, floats away on the waves
From which she will glean the answer

Her thoughts racing free, imagination
Unleashed, pure as a clear mountain
Stream tumbling down through these

Meadows of blooming wildflowers, as
A single hawk circles above, she feels
The wind stir the quiet of remembrance

21st Century Red, White, and Blues

How do we embrace this beautiful day, with a war blazing on the other side
Of the world; listening to the morning's birdsongs, a bright sun shining after
Burning off the fog; I drink in the slight breeze blowing in off the Gulf, I have
Plans to make, things to look forward to, there are no cluster bombs here in
Southwest Florida, at least not yet, I'm afraid of our country crashing into a
War of its own, uncivil and threatening all that we have built together, I feel
My stomach churning watching the fires rain down on Kyiv, wondering what
Would happen if that was Boston, Little Rock, Minneapolis, Miami, Las Vegas

Red states, Blue states torn asunder by our inability to no longer act as one
Nation, what is the state of our union? Am I diving into the quagmire of fear,
Displaced notions of a shared history, each state divided into two spheres of
Influence, called into battle by disparate visions of what life, liberty, and the
Pursuit of happiness means, America the beautiful standing too close to the
Cliff's edge, can we take a step back and breathe deep from the fountain of
Freedom, can we forgive each other without losing faith in what has come to
Define us; family, friends, and community, reaching out to help those in need

Small town football on a Friday night, big city neon lighting up the weekend
Kids dancing in the clubs, bars, and honky tonks, a plate of barbeque shared
With neighbors, a walk around the lake with a dog, a smile from a small child
The amen of a Southern church, hands raised in worship to a greater glory
Skating away on the ice of a new day under a crisp, cold Midwestern blue sky
Watching the surf crash on the coasts of the Atlantic and Pacific, people cast
Their lines from piers, docks, and shorelines, four wheelers and side-by-sides
Racing through pine and aspen forests along abandoned fire and mining trails

First communions, graduations, kids at the county fair, the swirling tilt-a-whirl
Mini donuts, Coca-Colas, corn dogs, french fries, a stuffed teddy bear under a
Young lover's arm, so much to be grateful for, thankful for those who have come
Before us, leaving behind their homelands in search of a better life, the scarves
And skirts in blazing colors, the young men watching futbol with a cold Modelo
The prayers and dancers of the First Nations, summoning the Great Spirit, the
Fruit and vegetable pickers sweating out the day's heat to feed our nation, in
Kitchens of diners, cafes, and restaurants the chefs and cooks working doubles

Servers and bartenders giving sustenance and care to construction workers and
Their families, roofers, painters, factory workers busting their asses to keep the
Rent paid and their families fed, the farmer harvesting corn in the late autumn
Sun, this is the America I know of, where we move in rhythm to our music, jazz
Gospel, blues, punk rock, hard rock, heavy metal, new wave, old school kicking
To the songs of our past and future; Louis Armstrong, Ella Fitzgerald, Bird,
Buddy Holly, Fats Domino, Chuck Berry, Elvis Presley, Public Enemy, Dead,
Beastie Boys, Jefferson Airplane, Sister Rosetta Tharpe, Hank Williams, Dolly
And Loretta, REM, Run DMC, Fleet Foxes, Father John Misty, O Jays,
Ronettes, Martha and the Vandellas, yes, there still can be dancing in the streets
This land is still our land, I hold out hope that it's still meant for you and me…

Against The Grain

Against the grain
We ride the tides
When the edges
Dissolve, turned
Out, time passes
By us, as we run

Against the grain
Each stone, but a
Link in the building
Of something that
Lasts, stilling the
Chill in the breeze

Against the grain
With nowhere left
To turn but to find
Strength in unity
Praising the bright
Light of morning

Against the grain
Silently glancing
To the blue skies
Above, and giving
Heed to a rhythm
That beats eternal

Against the grain
When our worlds
Collide, we must
Taste some joy in
Sanctuaries we'll
Find as we travel

Against the grain

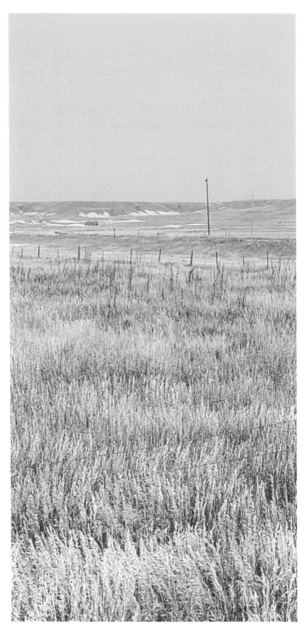

On the plains of South Dakota, headed towards the Black Hills

When It Went Awry

It went awry, then the love went away, left out on the thin light
Of sunset, withered on the dying vine, last heavy breeze, ripe,
The smell of decaying leaves, down near the river, kids drinking
A pair of crows jawing in the distance, solitary headlights, winter

Soon to be laying its burden upon the land, cold air so still, but
For just a broken moment, there she was, a youthful smile, her
Favorite song, Phil Lynott singing "Dancing In The Moonlight", on a
Hot summer's night, walking back to the party, hands entwined

Young hearts cast furtive shadows along the pastures edge, an
Old retaining wall waits to crumble into dust, and jagged pieces
Of limestone, time slowly slides into the void, between memories
Dreams, and illusion, tomorrow still but a glimmer, quick flashes

Of lightning, cold front moving in, first snow of the season, a fire
Burns in an old farmhouse, last train of the evening rumbles past
Rolling slow as it heads out of town and into a cold, bitter
Wind, as if the summer was just a hazy promise, lingering, slowly

Fading, quiet bonds of friendship lie tenuous, too many lines have
Been crossed, it's sadly slipping away between them, heads down
Almost like praying, not knowing where or who to turn to, this pain
Sears the soul, just a black heart sounding out its weary, sad refrain

Kerouac at 100

The myth, legend, man; 100 years next month
Born in smoking factory streets of Lowell, Mass
Now he rests eternal, words high in the stars of
A clear North Carolina night, back to the hearth
His mother's house, outside under the pine trees
He would meditate for a peace he never could
Find, could not forget his brother's death, yet
Always prayed for their deliverance; did his dance
With his demons begin then, just a boy confessing
His sins and confusion, his longings laid bare, lust
Forgiveness, absolution, baseball cards, and his
Love of football, hold that line team, here's Ti Jean
French Canadian halfback, ran from the frozen late
Fall fields of high school to a scholarship at Columbia
University, Manhattan, his career on the field over
But so many more fields to be discovered, a lifetime
Chasing some undefined grace, he and his fellow
Angel headed hipsters, Bull Lee Burroughs, Corso,
Cassady, Huncke, Ginsberg; street hustlers, junkies

Poets, drunk on life, hard booze, possibilities that
Split open in the clear American night, feeling out
The tones, rhythms, beats, Bird, Dizzy, and Trane
Damn the rules, you play all twelve notes in your solo
Anyways, a Love Supreme, always searching for a
Hit of that Love Supreme, in the calming grace of
Smiling Buddhas, or manic chords rising from bustling
Streets - New York, Denver, Chicago, New Orleans, oh
Those misty hills of San Francisco, across its bridges,
Golden Gate, Marin; East Bay, above the UC campus,
Trees and sun filtered through eucalyptus scented back
Streets, Berkeley, the shops and cafes of Telegraph Ave
Scanning west out to the Pacific, night shining, as if a
Jewel across choppy Bay waters, sparkling lights, seedy
Railroad hotels, a pint of pink tokay in his back pocket,
His struggle endured, heaven and hell, redemption or
Damnation, even as he communed with the spirits from

His lookout high above the fire line, desolation angel, his
Notebooks, and the animals, a government issued radio
Crackling with static on that Northern California mountain
Or lost in the Mexico City Blues, the road would not go on
Forever, his drinking worse and worse, losing his way as
He trembled in the fog of Big Sur, DT's and hallucinations
Eventually back into the arms of his mamere, disillusioned
Defeated, sweating out the last of his juices in a hot, Florida
Night, his life force spent from beer, brandy, and Benzedrine
No more riding on mercurial winds, backseat listening to Dean
Moriarty gunning a Cadillac, a black inked Midwestern night
Sipping water from the Big Dipper, a greasy back road diner
Burger and french fries, happy for the moment, smoke curls
In remembrance of the many generations he took on the road
Opening hearts and souls to the wonders of what may be, in
The still of a softly rising dawn, the ghost of Lowell's native
Son, moving again to a saxophone playing a song all his own

Questions Of War

It's cold inside the Armored Personnel Carrier, all that metal
Feels like one's trapped inside a giant refrigerator, all your
Senses on edge, the rumble of the convoy's engines can
Not ease the new conscripts' fears, what am I doing here?

They hold hands in their darkened apartment, a few lights
Shine on the horizon, air raid sirens puncture the late winter
Night, the war is at the edge of the city, tracers flash then
Quickly disappear, they wonder, how do we get out of here?

A creek meanders through the countryside, two soldiers on
Guard, cigarettes dangle from their mouths as they walk a
Fence line, peering far off into the encroaching twilight gray
No promises of what the coming battle holds, will I die here?

The bombs sound louder and louder, it's hard to tell what is
Happening up above, in the relative safety of this shelter, a
Mother tries to calm her children, they don't understand the
Meaning of war, just that Dad's gone, will he come back here?

So much wasted in the name of conquest, too many graves
Yet to be dug, lives taken, families blown apart, tears of pain
Now falling, like a rain that doesn't blow the dust away, a long
Time for the morning light to arrive, how did we wind up here?

Bear Trap

Will tonight be the night that the Russian Bear awakens?
The streets of Kyiv wait before them, the whole world is
Watching, impressed by the courage of these Ukrainians
Fighting off the troops deployed by a raging madman, how
Hard they have fought along the highways, bridges, and
In the forests, from small villages, to farming towns, the
Largest cities, undermanned but determined to fight till
The end; Russian boat, go fuck yourself, knowing fear is
Not the same as giving into to it, the morning has come
Again, they have not surrendered to the blood thirsty Putin
They raise themselves up with strong convictions, having
Been subjugated to the realities of war many times, and so
Tonight the rockets will fly again, Russia's brutality against
Their fellow brothers and sisters, war is such an ugly face
Of our shared existence, killing in the name of power and
Treasure, unfortunately when cornered, most animals will
Choose to fight, to save their home, their families, way of
Life, this conflict; so sad, so scary, such a waste of lives
The battle will soon rage again, damaged buildings, bombed
Out tanks, armored personnel carriers, trucks, and bodies
Lining the roads and highways where the Bear has tried
To attack their enemy, the wheat fields turning towards the
Planting and growing of spring, under the bluest of skies,
Can they hold out until the sunflowers begin to swell across
The countryside, trap the Bear in the cities and towns, use
Their high rise apartments and city streets as fortresses to
Unleash their own defenses; ambushes, molotov cocktails,
No quarter given, they have rallied around each other, they
Believe that they can sustain the battle long enough to win
The Russians are coming, but in many ways they have already
Lost, their currency collapsing, their tactics exposed, their
Will to fight in doubt, their conscripts young, far from home
The harshness of war - blood, guts, and death that surrounds
Them, their cause is not a just one, but one of generations
Past, trying to reach back to some mythic sense of greatness
The Bear claws his way towards destiny, will he be trapped by
Those who did not choose this war, but will fight to conclusion

In These Strange Days

Disjointed, so many thoughts swirling around me now
Seems like a heavy fog grips the valley floor, hoping
For the morning light to break through, lift me towards
Bluer skies, away from this misery and heartache, catch
Me if I fall, calm my fearful mind, walk beside me hand
In hand, longing for some healing touch, back away from
The abyss, we will wash our sins out in the river's waters
Feel the moss on the rocks as the current pulls at our feet
A little closer to the lessons of our savior, kindness, joy,
Compassion; casting out the darkness that fills us all in
These strange days, the path hidden, strong winds blowing
As we work our way through these bitter winds, meandering
A creek through meadows and pastures of plenty, first bulbs
Of spring pushing through to the surface, to once again be
Touched by life's many blessings, to ponder the mysteries
That rise before us, reflections of loss and renewal, to find
Redemption in the beliefs that move us closer to each other
Unraveling the riddles that come in our lifetimes, when loss
Is all around, to find strength, hope, and consolation, to learn
How to persevere as we wander onward, these strange days

Almost April

Misplaced remnants of battered hearts and sleepless nights
Threadbare treetops waiting for the sun to start them budding
This heavy gray morning, perched like dusty books on a shelf

City streets littered with discarded wrappers, water bottles, and
Cigarette butts, a lonely rabbit searching for shelter along this
Alleyway of feral cats and raccoons rummaging in the palest of

Moonlights, across the city a police cruiser's siren wailing in the
Distance shatters the calm of a late winter's evening, freight train
Rumbling towards its far away destination, carries away its cargo

Each wrestling with their own burdens as if the dream has become
A nightmare, sweat stained sheets, slightly opened windows, the
Whispers now a drumbeat, strong and persistent, like the last star

On Orion's belt, constant in the sky, shining meekly through March
Clouds, weary at the edge of springtime, waiting to explode in a
Barrage of colors that fill the day in purples, yellows, greens under

Brilliant skies of blue, the city needs its renewal, leaving behind icy
Trails that the neighborhood dogs made chasing frayed toys and
Hiding a flowing creek under the snow's hard crust along the path

The seasons know nothing but their own arrivals and departures
Tracing out quick deceptions and halting getaways, Prince sang
It sometimes snows in April, but we're just stuck in the mire of this

Day, a cold wind blowing through the workers waiting for their bus
Searching for shelter in thickets of trees and bushes, the daylight
Begins creeping on the horizon's edge, the city slowly stirs again

Daybreak over the Myakka River Basin, Port Charlotte, Florida

Fallen

Fallen, left for dead on the city sidewalk
Fragments of a life, that only their friends,
Family remember; the body torn apart by
Enemy fire, these are the spoils of war, a
Pool of blood dripping down into the gutter
Artillery shells bursting from a distance, the
Shock wave spreading through the quiet
Farming village, the rumble of tanks, small
Arms fire ricocheting off stone walls, trails
Of dust rippling where not so long ago peace
Held the early morning sun in hands of time
Eternal, the planting season should be soon
Coming, seeds of life, planted in the country
Fields that fed the nations and gave worth to
A long days work, silenced by the wrath of
Bombs exploding, missiles flying, alight in the
Deep, dark night; time once more stands still
As families hide in the barns and outbuildings
Passed down from generation to generation
The efforts of many families working on their
Land, apparitions of prior battles, glow on the
Edge of the firefight, this land has seen war
Before, death is but a stark reminder of what
Happens when power and might collide, to
Impose a will unwanted, laying waste on victims,
Casualties, statistics counted on the devil's watch
Broken bones, broken lives, broken families, it
All pours out in a child's tears, a mother's grief
A torment that will bring about a lifetime of fear
Hatred burning in the souls of the killing force
Now passed over to those they have harmed
The cycle begins again, death passes through
A once peaceful village to leave it destroyed in
The slaughter of innocents, the bloodstained
Hands of time, now descending, gone, another
Precious life, fallen, to the brutality of this war

Happy Birthday Soul Cyclone

He's a superhero who doesn't like to wear his pants
When he goes out on a secret mission, into the clammy
Waters where his friend Sponge Bob Square Pants
Lives and he likes diving into the pool when no one
Is watching, and he can fly into the clouds and dream
He's the master of his own world, watch as he heads
Into the lights, see the Soul Cyclone spinning across
The Florida skies, spinning to be free, the Soul Cyclone
Was so happy, as the crowded restaurant began to cheer
Happy Birthday Ethan Zurbo, pounds the table like a
Drum, his moment in the spotlight, the Soul Cyclone's
Dancing in his father's arms, his smile lights up the room
Such a beautiful sight, this moment of love and hope
In a world that must be hard to handle, the superhero
Soldiers on, he must keep on trying to save the world
Soul Cyclone's happy moments, McDonald's french fries
And a Coke, every child needs to spread their imagination
Every child must ride up amongst the stars, the Soul Cyclone
Keeps on spinning, riding the whirlwind he creates, perhaps
One day the Soul Cyclone will wipe all the bad away, keep
On keeping on Soul Cyclone till your birthday comes again

Indian Rocks Redux

Like the pedal steel cuts through the sounds of a honky tonk
The mourning dove divides the day, its plaintive moan on the
Electric wires bittersweet and haunting, old memories come
To life, of spring breaks long ago, the smell of sea breeze
The sound of pelicans and gulls, swirling along the sandy beach
My Dad and Grandad drinking Buds and slurping oysters at a
Pierside bar, watching the Twins against the Phillies in the
Grapefruit League, vivid in my mind, these flashing images
Soaring as if a note from the mourning dove resides inside

No Longer Just Kids

Your heart broken, but spirit unbowed, gung ho, still grateful, searching for
Truth in moments of blessed inspiration, like Blake, Whitman, and Rimbaud
Before you, transcending the mundane in pursuit of transformation, you have

Faced loss with grace, your best friends Sam and Robert, your brother Todd,
Peers Kurt and Jerry, your mentor Sandy, and your husband Fred Sonic Smith,
You keep dancing barefoot to rhythms of a greater muse, Johnny rides off on

Horses, horses, horses; the carnival and carnage chasing the apparitions into
The year of the monkey, you misplaced your keys to the Dream Inn, riding the
Surf of Santa Cruz into the desert's mirage, a laconic cowboy disrupts your
sleep

From the chilly winds of Lake Michigan, to the soot of the refineries, outside
Philadelphia in the wilds of South Jersey, you left behind the piss factory and
Searched for your voice in the sweltering Manhattan heat, your room inside the

Chelsea Hotel, run-ins with Janis, Jimi, and Jefferson Airplane; poised for flight
You took off with help from your guitarist Lenny Kaye, still partners in song
After fifty years, ripped jeans, black leather jacket, and white t-shirt

Ready to explode, a comet burning bright above a New York summer night,
Love, the banquet on which you feed, spinning, a whirling dervish, navigating
The highs and lows, tracing out your steps to this ghost dance

Mill City Reflections

I hop onto the 4 bus
Such a late spring
Tulips still blooming
Down at Loring Park
City kids playing ball
Riding on long boards
Having fun, lots of folks
Walking on Nicollet Mall
Workers having a smoke
Weed dealers, hustlers
Beat cops, out of town
Twins fans, tourists
There's a hassle at the
Light rail station, Metro
Transit and MPD cops
Dude in cuffs, checking
Through his pockets, a
Bottle of Karkov by his
Feet, off to detox he goes

Here comes the Green Line
Past the Courthouse, Armory
Slithering through the edge
Of downtown to the U of M
Past 7 Corners, West Bank
Ghosts, 400 Bar, Bullwinkles
Preston's, Gramma's, Winners
Back when I was young, friends
Out drinking, dancing, smoking
Buttslashing the locals, skull
Gardens and sweat barns, the
Bands played on; The Suburbs
Huskers, Cats Under The Stars
Ipso Facto, Widgets, Jayhawks
Soul Asylum, Westies, Blu Hippos
Hoopsnakes, Picadors, Pleasure
Delilahs, Cows, Maroons, TVBC

Babes, Zuzu's Petals, and Mofos
Rocking out, down in the pit

We cross the Big River, water's
High from the recent storms, the
Grass turning a deep green and
Oak trees filling in on the plaza
Coffman Union, Stadium Village
Williams, Ridder, and Mariucci
Go Gophers go! I get off at the
Stop outside the new football
Stadium, but I used to love the
Old one, the Brickhouse, where
My family would drive up from
Rochester, eating at Little Oscar's
Black Stallion or Edgewood on
The way home, dreaming under
Big prairie skies, stars twinkling
In the jet black night, time refracts
My thoughts, now seared into
Memories, intertwined and lost to
The winds, I pause before walking
Through this city that I've come to
Love

Downtown Minneapolis in the Golden hour from the West Bank of the Mississippi River.

Roadmaps

Mapping out our lives, circuitous, torn out at the corners where
The wild living was done, hot sauce stains on the memories of
Ghosts and apparitions, left hanging on the steel breeze, what
A trip, long and strange indeed, I felt like we were falling, but
We had already fallen apart, still, what matters remains, these
Mornings lost to reflection, and the innocence of our youngest
Selves...

Rain Down On Me

Rain down on me
Throw me to the cold
And mists again, is that
Your voice calling from the
Alleys we once scoured on our
Way home from last call at the local

Rain down on me
I'm hurting but resilient
The cold blasts, November
Winds blow hard as I walk to
Hennepin and 26th, to wait on the
Last bus to take me across a tired city

Rain down on me
Passing by smokers at the
Doors of bars in fading neons
Laid out like fallen angels ready
To fly once more into autumn's wind
We slide into silence, where night rests

Stone Arch Bridge

From up above the Mississippi
Ghost lines running downtown
Tumble into history, river rolls,
Rolls, rolling, on and on and on
Downstream, looking behind you
The falls of St. Anthony, melting
Snows of winter, swelling river, a
Crisp April day, Northern winds
Sweep hard down the prairie, now
Impervious to the changes, as time
Stretches out like the first barges
Moving upstream, the valleys of
Tributaries swiftly flowing into the
River basin, patiently, night awaits,
Its vibrant colors, splayed out along
The horizon, night begins to sing

Christmas In The City

Inching slowly, cautiously attuned
To all of this cacophony around you
Present in the moment, voices rise
Up to meet you as you walk a busy
City street, buses and delivery trucks
Snaking through the morning rush of
Traffic, another work day beginning

The season's lights flicker out jovial
Greetings, window shopping along the
Mall; the tinsel, boughs, and garlands
Christmas in the city, as you think about
Gifts for your family, to share the bounty
You've received, reveling in our blessings
Praying for peace on earth, good will to

All, a gentle snow begins to fall, another
Year will soon come to pass, sharing a
Drink with old friends back to see their
Loved ones, a drop of holiday cheer to
Still the pain of family and friends who
Have departed this mortal coil, sustained
Now by their spirits deep inside our souls

This life of simple pleasures, the kiss of
A friendly dog on your cheek, sunlight on
An icy lake, scented with birch and maple
Woods burning in a fireplace, kids playing
Street hockey or shinny on a frozen pond
Traditions of the season endure the test of
Time, like songs our grandparents taught us

The Big Easy

Many have dipped their fingers into the waters of the Mississippi
River, Lake Pontchartrain, Lake Maurepas; French, Spanish, German,
English, Irish, Creole, Acadian, Free Black, and slaves; the names and
family stories on Mausoleums and headstones that fill the cemeteries
of New Orleans, history hanging on fingers of Spanish Moss, and in
the rhythms of the Second Line, calling out to wraiths, ghosts, spirits
that linger like the sunset and steal away into night

The land was fertile and sugar cane the cash crop, chopped down by
Enslaved men and women steamboats brought cane and cotton down
The rivers and bayous to the Port of New Orleans, where dockworkers
Toiled on the wharves, loading and unloading vessels bound for the Gulf of
Mexico, then the Atlantic Ocean, to the factories of the American North,
South to the Caribbean and across to Europe, fortunes were made as the
Finance, insurance, and legal industries grew

The city did too, Napoleon sold New Orleans as part of the Louisiana
Purchase in 1803, and now, America took over the Louisiana Territory,
Before being admitted to Union in 1812, slavery continued to escalate
In the region and Louisiana was the largest slave holding state by 1840
In the Civil War, Louisiana joined the Confederate States, seceding from
The Union in January 1861, only to be captured by Union forces in April
1862, as the Union divided the South in two

The city divided as well, the French Quarter home to the Creoles and French
Speaking people while Anglo-Americans took root in the Garden District, and
Today's Central Business District Reconstruction gave blacks a chance at a better
Way of living, but segregation became a way of life following the withdrawal of
Federal troops in 1877, lasting until the Civil Rights era of the 1960's, today the
Divisions are stark, poverty and affluence commingling throughout the city

Culture began to flourish in the late 1800's, New Orleans a haven for artists,
Writers, musicians jazz came alive in the streets and bars in the early 1900's,
Paving the way for blues, soul, funk, rhythm and blues, and rock and roll,
All bubbling up from the diverse influences the city holds as does its food,
Home to the Po-boy, gumbo, oysters raw and smoked, etouffee, beignets, and
Chicory laced coffee, the city more than holds its own as a culinary

Capital, rich in its flavors

Today New Orleans stands as a testament to all of those who shaped the city's
Past, present, and future, walking through the Quarter and its colorful buildings
And homes, riding on the Canal Street trolleys out to Mid-City with its
City Park and museum, time floats, the railroad still moving product to the
Port, tugboats, and seabound vessels blowing their horns in the hazy shadows
and muddy waters of the Mississippi, the Big Easy marches on and on

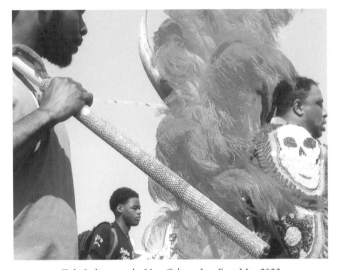

Zulu Indian parade, New Orleans Jazz Fest, May 2022

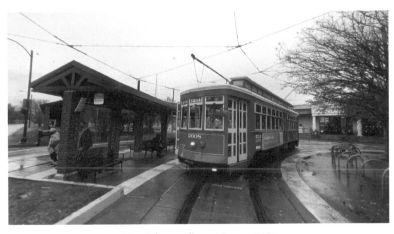

New Orleans trolley car, January 2022

MLK Day

Spring break 1968, our cities alight with fires, riots, and violence in the
Streets too young to understand what was really happening, watching on
My Grandpa's old console television, safe on the shores of Clearwater Bay,
The news was somber The Reverend Martin Luther King Jr., dead from an
Assassin's rifle, Lorraine Motel Memphis, Tennessee, he had now crossed
Over that mountain top, besides the riverbend a choir singing, Oh Precious
Lord, Jesus had taken another brave man

Home, where there was no hate, where there was no lesser than, no segregated
Bathrooms, restaurants, or water fountains, no crosses burning in the warm,
April night; just the sweet song of birds rising up to touch the morning,
heaven
At last for the man who fought segregation, who showed what the character
Of his calling was inside of his journey, from the streets of Birmingham, to
Nights in the city jail he kept on keeping on, secure in the knowledge of his
Faith and a path leading to

Righteousness for all, the desecration of America's original sin, the one that
Still stains and subjugates today, the shifting of our promise from life, liberty,
And the pursuit of happiness, to a cry that brings back the horrors of yesterday,
The charlatan shuffles the deck to reveal the nightmare still alive in our country's
Heart and soul progress, what of progress, it feels tentative, and shaky these
Stress filled days backsliding into the future, no water for you while waiting in
Line to vote, so many

Moments that were seemingly gone forever now raise their ugly memories
again, 60 years since the March on Washington, where did our hope go,
did it die From neglect, or worse, did we just throw it all away? Our heroes
are passing on, the pull of time forces us to confront our mortality, and the
legacy we leave Behind, still struggling, still pushing forward, not going
gentle into the path less chosen we will gather by the river once again and
sing the songs of sacred bonds, not going

Out without a fight, like the sanitation workers of Memphis as Dr. King
made his final stand, hope needs but a spark to turn into the flame of
change, to right these American wrongs, to turn our faces to the damage

left where the grapes of wrath are shorn, to live up to the challenges we face each and every day, to rise up on eagles' wings, and stare down on the vast and fruited plains where brave men and women wzalk; with the faith, hope, and fury of Dr. Martin Luther King raining down on this land

Outpatient Maintenance Blues

The lights were bright inside the clinic, the line was long to see the nurse
Various counselors shuffled about, our men's group was meeting in twenty
Minutes, I was hoping to get my medicine before I went to group, the crowd

Was getting agitated at the slow pace of the intake desk, Mondays after a
Holiday weekend were always busy, funny that you could wait an hour in
The snow or 10 below zero, for your dealer who was always late, but you

Couldn't wait fifteen minutes in a heated waiting room, watching the numbers
Click down on the closed circuit monitor, 111069, only four more in front of
me
I was going to get my dose before group, I could feel the tension ease from my

Shoulders, as the tension inside the room kept rising, I was just starting to
come
Out of my fog, my brain clearing after three months of no junk, coke, oxies
I'd been here before, like school years, 2003-04, 2009-10, 2013-14, third
time's

A charm, I sat in the first chair besides my counselor Irv, a good man, picked
Up his habit in Vietnam, brought it back to the World when his tour was over
Got clean, used the GI Bill to go to college, got his counseling degree, now he

Tried his best to help us get clean from our habits, our sickness, diseased and
Some of us trying to beat our own cycles of addiction, some just trying to stay
Out of jail or prison, court ordered, trapped up deep in the game, the life
holds

A dangerous pull, it's tough to breakaway, or just break through, to recognize
What led you back to this hellhole, the burning in your soul, wreaking
havoc on
Everything around you, till you get that next hit, next fix, next pill, next, next

Tomorrow, today, yesterday, forever; you've now got the stain of a million lies
Churning as you lay awake at night, sleep doesn't come easy, if it comes at all
Something between a zombie and a livewire twitching, you catch a couple
hours

In the gray of the impending dawn, before catching the University express bus to
The clinic, another day begins, relapse prevention group today at nine, you must
Learn to face yourself, another day with the outpatient maintenance blues again

A Rocker's Requiem (For Taylor Hawkins)

In the van back to the hotel, adrenalin still pumping through
Your system, your room a solitary sanctuary for a few hours
Booze and pills and powders, feel their potency enveloping
All in a gauzy film of gossamer, slowly peeling away your
Defenses, staring out the window as the night turns to day
Remembering the heights the band reached together and
The lows you're forced to face alone, your family thousands
Of miles away, the comings and goings of life on tour, this
Delicate armor, such a double edged sword, falling through
The cracks, left to our own delusions, deceits, dreams, and
Derision, the battle between the joy expressed, and the pain
Shared, caught between the extremes of blessed, tortured
Life, moving to an internal rhythm, falling through the cracks
As you try to outrun the darkness, such a distance from the
Promise of another sunrise, you fight your demons all alone
Chasing after the inexplicable, with noone to share the fears
Or pass back a shot of courage, languishing, in a sleepless
Bed, descending into the misty shrouds of madness, holding
Out for a bit of peace and solitude, waiting for a gentle breeze
To take the pain away, but left to face the winds of another day
Swirling, another bus ride or flight to the next show, the road
Rides on forever, until the curtain finally drops on the stage
The last encore echoes, as you slip into the arms of lonesome
Angels, riding to the sounds of a gentle morning rain, now left
With the heartache of all you've left behind, flying on the wind

Venus

Venus, last light of the evening, still high in the dawn sky
About to be thrown aside, fragments of orange and blue
Pushing out along the horizon, watch as the new day rises
Wondering wherever the day shall take us, ripe with infinite
Possibility, the promise of last night's dreams still moving
The morning dew has kissed the land, and while all seems
Calm and quiet, listen to the songbirds singing through the
Tree lines, no time to wallow in worry or despair, this day
Awaits their simple blessings, moments of clarity and joy
As this corner of the world awakens in the notes of this
Minnesota morning song

Springtime in Rochester

The slow turning is almost over, snowbanks dissolving into streams
Where the neighborhood children chase down little boats into gutters
Full of last autumn's leaves, ripe with six months of decay, weighted
Down by October's brilliant reds, oranges, and yellows; an older dog
Sniffs the air as its owner walks it down tree lined streets reaching
Out to meet the sun's warmth, oblivious to the change waiting to be
Unleashed; April's mix of sun, snow, and rain, first bulbs and tulips
Breaking through the crusty soil and spreading colors across city
Streets, avenues, alleys; a father teaching his kids to ride their bikes
The sounds of life echo through time and space, who will make new
Memories, and who will wander back through their past, faded glory
Our little league games and practices, kite flying on the fields in front
Of Kellogg Junior High School, nothing but puffy clouds sliding above
Crisp and clear, the sun may be warm but this wind still holds its chill,
I breathe deep, letting myself follow in the swirling string, loose on a
Breeze that propels me skywards, floating above it all, I see houses
My brother, sister, and I grew up in; our neighbors too, Perry's, Gores',
Stillwell's, Sheridan's, Luchau's, Sedlack's, Osmundson's, Ferguson's
Street hockey games in the soft grays of twilight, home run derby, and
Kick the can, hearts and imaginations running wild, putting on a brand
New uniform, first game of the season, Coach Miller trying to mold us
Into a winning team, my glove hooked onto the handlebars of my green
Schwinn Stingray, riding up to the ball fields at Quarry Hill Park where I
Would later drink my first beer, Schmidt Scenic Sportsman's in a warm
Can, playing in the caves and quarry, riding our bikes along Silver Creek
Swimming in the pool at the park, twenty five cents for a Coke at the IGA
Candy and ice cream at the dairy stand behind Hunt's Drug and the Ben
Franklin, lost in this reverie, seared into my mind, scattered images of a
Boy, and his friends, open to the possibilities of springtime in Rochester

Solid Country Gold

There stands the glass, neon lights, chicken wire fences in front of
An old raised stage, sawdust on a parquet dance floor, couples do
The two step as a steel guitar splits the night, smell of fried chicken
French fries, onion rings from the kitchen in the back, pool tables on
The side, parking lot keeps filling as the purples, pinks, and oranges
Fill out edges of the horizon, first star settling softly into space, Mars
Chases Venus across the sky tonight, listening to the sounds, solid
Country gold coming from the bandstand; Hank, Waylon and Willie,
Loretta, Dolly, Tammy Wynette and Patsy Cline, The Ol' Possum, JR
Cash, Ray Price, Wynn Stewart, Buck Owens and The Hag, Connie
Smith, Kitty Wells, Bobbie Gentry, Cowboy Copas, Hank Snow, Eddy
Arnold, Gentleman Jim Reeves, Roy Acuff, Chet Atkins; songs of love
Songs of drinking, songs of cheating, working man and woman blues
Passed down from generation to generation, hope, heartbreak, trouble
Toil, sweat, passion, pain, happiness; a fiddle takes a solo as couples
Shuffle on and off, Lone Star beer and big brass belt buckles, a Texas
Full moon night, there'll be cussing and fighting later as it gets closer
To closing time, jealousy doesn't mix well with whiskey, though tequila
Doesn't pay much mind, the couples clinch a little tighter, the band is
Almost through, church first thing tomorrow morning, from the hymnal
They'll be singing, on an uncloudy day they'll fly away, but soon they'll
Be thinking about next weekend, and songs full of solid country gold

Up To Calvary

The choir sang, rise up, rise up to victory, rise up, rise up to Calvary
Nine minutes under the bended knee, Momma, Momma, I can not
Breathe, my city in flames, I can hear the Black Hawks circling up
Above the freeways, the National Guard convoys passing through
The neighborhood, three days of rage, torn open the scabs that now
Bleed out in the streets, I smell the fires of the stores, Post Office and
Wells Fargo off of nearby Lake and Nicollet, dark plumes billowing as

The choir sang, rise up, rise up to victory, rise up, rise up to Calvary
Anger, anguish, and grief; another brutal, violent scene, where will it
End, dreams deferred, dreams destroyed, another life taken before its
Time, splayed out near the corner of 38th Street and Chicago Avenue
Four officers of the MPD, watch him die at their feet, dark thoughts run
Through Chauvin's mind, threatening those who attempted to stop the
Killing of Mister Floyd, last gasps of air flow from his lungs, laid low, so

The choir sang, rise up, rise up to victory, rise up, rise up to Calvary
The preacher in the pulpit; dignitaries, politicians, and family listen as
The cadence grows faster, from a whisper to a shout, the faithful point
Up above, a divine spirit picks up the song, silent angels wait to spread
Their wings, filled with the power of the reckoning, the time of the Lord
Is close at hand, the lion has killed another lamb, a life now ends to the
Heavens he'll be set free, another young daughter left without her Dad

The choir sang, rise up, rise up to victory, rise up, rise up to Calvary
The congregation hurting, the preacher begins to pray, Lord we are tired
Tired, tired of the young men dying, we are tired Lord of the fighting in
The streets, can we rise up, rise up to victory, rise up, rise up to meet
Jesus waiting for us at the throne, there upon the golden shores, by the
River we will meet, rise up, rise up to victory, the time is now to stop our
Madness, let's rise up, rise up to victory, we'll rise up, rise up to Calvary

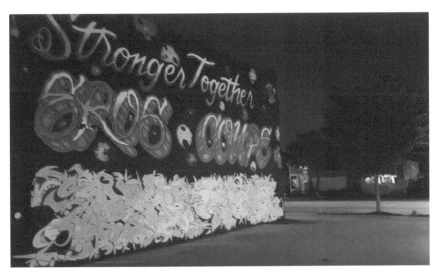

Unity mural in the Wedge neighborhood of Minneapolis following the George Floyd incident in Minneapolis Attachments area

7/4/78

Little kids were playing kick the can and king of the hill while
Dads were drinking from the keg,smoking stogies, Camels,
Marlboros; Moms were hitting gin and tonics as they bitched
About the picnic, some puffing Kool's or Winston's sitting
In the shade of a large Oak tree, teenagers lingered about
Trying to sneak a beer from the keg or cooler, hoping someone
Had a big fat joint, or at least a couple bowls of Colombian to
Get stoned, without one of the neighbors clamping down on
Their fun - 4th of July, 1978, two years since the bicentennial
America raged in all its polyester and pleathered glory, gold
Chains, chest hair, Aqua Velva, Brut by Faberge, can't forget
Old Spice, look at Lars, his short shorts spilling his balls out
Of their fringy laces, poodle perms and feathered Farrahs, who
Knew there were so many uses for unnatural fibers and petroleum
Byproducts, Altamont may have killed the 60's but the 70's were
Dying on their own - disco, punk, New Wave waited for the arrival
Of the video star, hard rock was getting softer, and metal went
Snowblind, shit was starting to come apart in the suburbs, it
Seemed all mixed up, hearts of broken glass, dancing just to
Keep staying alive…

Elegy For The Monk

The first birds singing their morning
Songs, the world turns to face the day
A sadder place without your dancing
Feet and smile Dan, rest in peace Monk
I know how much we are going to miss
You, swing through the trees of heaven
My friend, your spirit now resides inside
Us, see you on the other side brother

About The Author

Cray McCally is a poet, essayist, and cultural historian now living in Minneapolis, Minnesota. Originally from Rochester, Minnesota, he earned undergraduate degrees from the University of Minnesota in History and American Studies, and a Master's In Liberal Studies from Metropolitan State University, St. Paul, Minnesota. This is his second collection of poems to be published; his first, Weapons Of Illusion, was published in 1994 by Lex Press, Los Gatos, California. A former cook, bartender, and hotel industry worker, his written work focuses on the relationship between the individual and their communities at large. A longtime fan of music, University of Minnesota sports, and the food of America; he hopes to capture the uniqueness of daily American life in his writing.

Ingram Content Group UK Ltd.
Milton Keynes UK
UKHW050636070323
418150UK00009B/93/J